Whitby Abbey

Steven Brindle

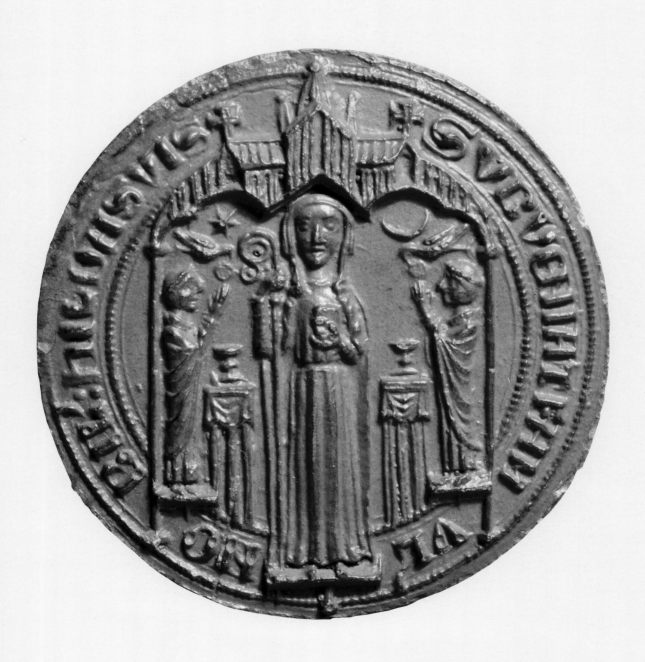

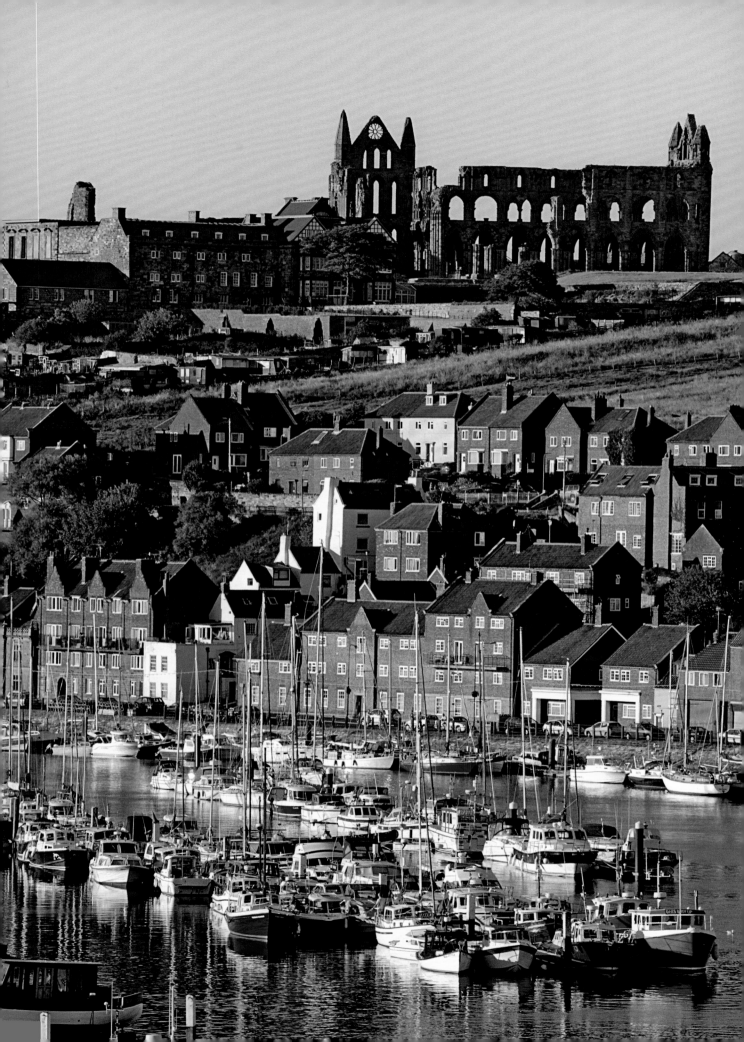

Introduction

The huge, gaunt shell of Whitby's abbey church is one of
Yorkshire's most memorable landmarks, visible from miles away
from land or sea. Yet the monastery only represents a part of the
headland's history. People have lived here since at least Roman
times, when there was probably a signal station on the cliff edge.
In the seventh, eighth and ninth centuries there was a thriving
Anglian community here, with a famous minster (or monastery)
of monks and nuns, founded by St Hild, at its heart. Archaeological
excavation has revealed abundant evidence of them, although
much remains mysterious. The minster and settlement had
disappeared by the end of the ninth century, presumably following
Viking raids along the coast. The name 'Whitby' is Danish: the
present town, down by the harbour, was almost certainly founded
by Danish settlers some time in the 10th century.

The great Benedictine monastery dominated the headland
and the town below from its foundation in the late 11th century
until its suppression in 1539. Its site and the surrounding estates
were then bought by the Cholmleys, a newly rich landowning
family. They demolished the monastic buildings but preserved the
shell of the church, and adapted the former abbot's lodgings as a
residence, adding a grand new wing to it in the 1670s. This forms
the other main complex of buildings on the headland.

In the later 18th century the Cholmleys moved away, but by
then the shell of the abbey had become a picturesque ruin and
a historic monument, and in the 19th century Whitby became
a tourist destination as well as a thriving port. The town also
provided a setting for Bram Stoker's 1897 novel *Dracula* and
the ruins continue to inspire modern-day 'Gothic' culture. In the
20th century, the abbey was placed in the care of the Ministry
of Works, and in 1984 the ruins were transferred to the newly
formed English Heritage.

Above: Fragments of
late medieval glass from
Whitby Abbey, pieced together
in the 19th century, and
now in Whitby Museum

Facing page: Whitby
Abbey from the south, seen
from across the harbour

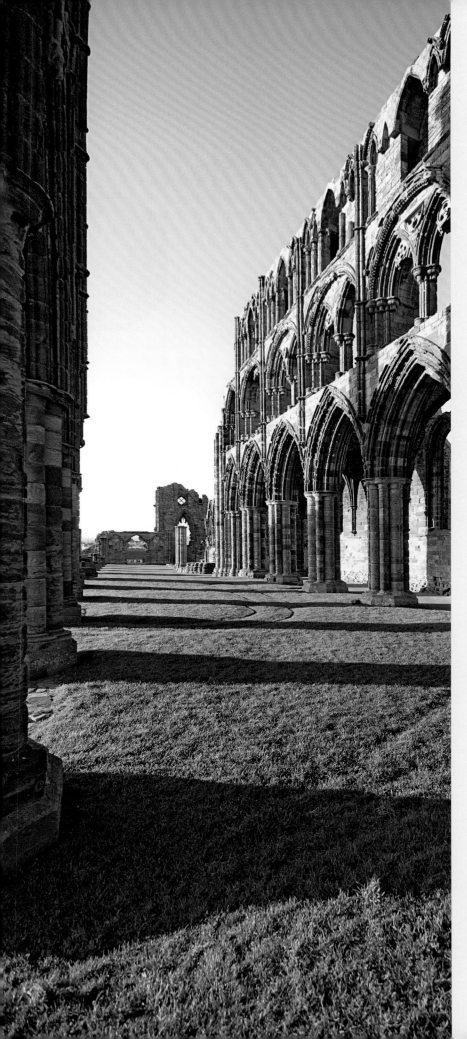

Tour

The shell of the abbey church stands in splendid isolation in a way that is historically misleading: it was originally the focus of a large complex of buildings, which have now mostly disappeared.

The whole site was surrounded by a precinct wall, the line of which is largely preserved in the modern boundary walls. The abbey ruins date mainly from the 13th century, but people were living on the headland at least 1,000 years earlier.

The headland itself has changed during this time. The cliff edge is being eroded at a rate of around 10m every 100 years. In Roman times the headland might have extended out by another 200m or more. Today, the land rises as it approaches the cliff edge, and it is likely that the lost part of the headland rose higher. So the site of the abbey, which now seems so windswept and bleak, might have been protected from the gales by the slope.

FOLLOWING THE TOUR

The tour starts with an overview of the Anglian discoveries on the headland, and then explores the abbey church and adjacent Abbey House. The small numbered plans in the margins highlight key points on the tour.

ANGLIAN WHITBY

In the seventh and eighth centuries, the headland was the site of an Anglian settlement and minster church. The name 'Anglian' is used to distinguish the people who settled on the eastern seaboard of Britain in the fifth and sixth centuries from the Saxons and Jutes who arrived further south. The minster was founded by King Oswiu of Northumbria (d.670) as a thank-offering for a great victory, which had safeguarded the future of Christianity in northern England. It was one of a number of monasteries established at river mouths, along with Jarrow (on the Tyne), Monkwearmouth (the Wear) and Hartlepool (the Tees).

Excavations have revealed evidence of a thriving settlement here. In the 1920s, Sir Charles Peers excavated the abbey church and the area around it. He found the foundations of several rectangular stone buildings in the area immediately north of the church, but their function is not yet clearly understood.

In the 1990s, English Heritage carried out excavations on various parts of the headland.

Near the cliff edge, there were traces of substantial timber buildings, parts of which had already fallen into the sea. On the westward slopes, overlooking the harbour, there was evidence of terracing, with numerous timber houses and enclosures. There seem to have been no springs or streams on the headland, so rainwater was collected in stone-lined cisterns, several of which have been found. Excavations on the site of the visitors' car park revealed a large Anglian cemetery, with hundreds of burials dating from the seventh and eighth centuries.

From these elements, an outline plan can be put together of the lost Anglian settlement, although it has not been possible to identify the site of the Anglian minster positively. It is not clear when it ceased to exist, but it was probably destroyed by the Viking raiders who began to attack the east coast in the mid-ninth century. By the 11th century the settlement on the headland had died, and had been succeeded by a new town down by the harbour with a Danish name: Whitby.

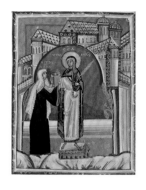

Above: An 11th-century German manuscript illustration of Hild (or Hilda), Whitby's first abbess (on the left), offering the gospel to St Walburga

Below: Modern plan of the Whitby headland showing approximate locations of Anglian features, as found by excavation, in red

Facing page: The interior of the abbey church, looking west

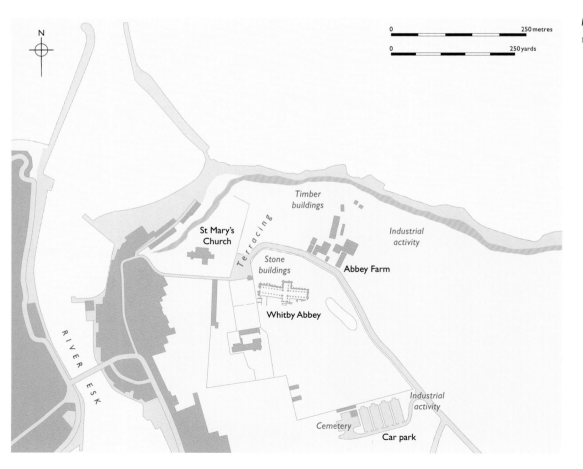

Life at Anglian Whitby

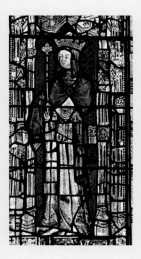

Men and women, often of noble birth, gave up their wealth for a life of 'regular discipline', ruled by the abbess

Above: St Hild, depicted in early 14th-century stained glass at Christ Church Cathedral, Oxford. She is shown as a princess, with a crown and sceptre

Minsters – important churches with religious communities attached to them – were the central religious institutions of Anglo-Saxon England. As at Whitby, where Hild was appointed by King Oswiu, minsters usually had royal founders and were often ruled by abbesses. Whitby was a double house for both monks and nuns, probably living in separate areas. This was typical of Anglo-Saxon culture: other double houses were founded in the seventh century at Hartlepool, Ely and Barking, all ruled by famous abbesses.

Men and women, often of noble birth, entered minsters voluntarily, usually giving up their wealth and possessions for a life of 'regular discipline', ruled by the abbess. Sharing the menial tasks of the house, in the kitchen, the garden, or working the land, they worshipped together in daily services, but much emphasis was also placed on private prayer and devotion.

Hild's community at Whitby flourished from its foundation in AD 657 until an unknown date in the ninth century. We know little about its layout, but later chronicles describe it as having 40 or 50 stone cells, and the archaeology suggests that these would have been surrounded by a number of timber buildings. It is likely that there would have been an enclosure around the minster community, although no evidence of this has been found. Archaeological finds show that there were numerous craftsmen working in stone, metal and wood and making ceramics and textiles. The metal objects are especially fine, although we do not know whether the craftsmen were members of the minster, or if they lived in the community outside its gates.

Whitby stood above an important harbour, and the pottery evidence demonstrates that it had international trading links. Kings and nobles came to pray and seek advice, and the minster became the main royal place of burial for Northumbria. King Oswiu and his family were buried in the church at Whitby, as were the remains of King Edwin; he was originally buried near where he was killed at the battle of Hatfield in South Yorkshire in AD 633, but his bones were rediscovered and moved to Whitby much later. Whitby also had links to religious houses on the Continent. In the late seventh century Abbess Ælfflæd wrote a letter of introduction, which still survives, to Adolana, abbess of Pfalzel in the Rhineland, on behalf of another English abbess, who was making a pilgrimage to Rome. Its polished Latin and perfect calligraphy testify to Whitby's high standards of culture and learning at this time, as well as its international connections.

Anglian objects recovered from excavations at Whitby

1 Fragment of an eighth-century stone cross with the inscription 'orate pro' (pray for)
2 Key
3 Bone comb
4 Decorated stylus, used for writing on wax tablets
5 Decorative mount or clasp for a book cover
6 Decorative mount for a book cover
7 Silver strap-end

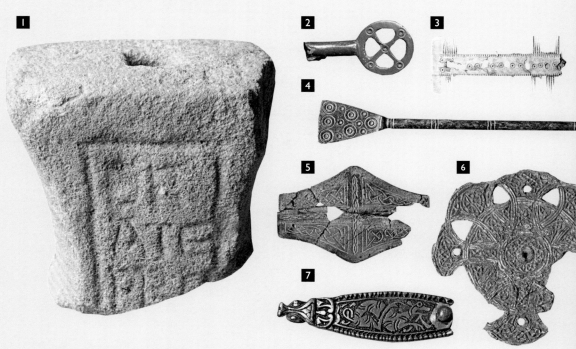

◼ THE ABBEY CHURCH

The ruins of Whitby Abbey that can be seen today date from the 13th century onwards. The first Benedictine church on the headland was a smaller, but still impressive, stone building in the Romanesque style, probably begun in about 1109. Excavations in the 1920s revealed some of the foundations of this previous church, including its eastern arm ending in a semicircular apse, flanked on either side by chapels, also with apses, which open off the transepts. The foundations have been partly reconstructed and partly marked out in the grass by the Ministry of Works. From the east, the Romanesque church would have presented an impressive row of five apses, each housing an altar, with the high altar in the central one.

A surviving doorway, just south of the west end of the nave, can be dated by its details to the 12th century. This suggests that the Romanesque nave was as long, or nearly as long, as the later Gothic one.

The 12th-century church at Whitby, with its five apses and long nave, followed a classic Benedictine design, ultimately derived from the great monastery of Cluny in Burgundy. Versions of the five-apse design were built in a number of Benedictine monasteries in Normandy, such as Bernay and Saint-Etienne at Caen, and the latter's English offspring, the 11th-century Canterbury Cathedral. English churches, such as Whitby and its sister house, St Mary's Abbey at York, represented variations on this theme. There can be little doubt that Whitby's first abbot, William de Percy, had obtained the services of a Norman mason, to have such an up-to-date design.

The Romanesque church stood until the 13th century, when abbots, priors and bishops all over England were launching ambitious projects to rebuild what, in most cases, were already large and impressive churches. It seems likely that a spirit of competition mingled with a wish to demonstrate their devotion to God. Abbot Roger of Scarborough, who probably ordered the rebuilding at Whitby in the 1220s, would have been aware of what was happening at other monasteries, and this is one of the keys to understanding why this great building came to be here. Whitby's abbey church, dedicated to St Peter and St Hild, was more than 90m long – the size of a small cathedral (Ripon Cathedral is about the same length; Carlisle Cathedral was 96m long before the loss of its nave). It was magnificent, but it was not unique.

The abbey church was not built primarily to serve the local community. The town was served by a large early 12th-century parish church, which had itself been provided by the abbey, and which still stands (see page 27).

After Whitby Abbey was suppressed in 1539 the monastic buildings were completely demolished by the Cholmley family, who bought the site and much of its estates. The body of the church, however, remained standing in its entirety: it is not clear why, but it may have been valued as a landmark for shipping. An early 18th-century view shows the shell of the church still complete (see page 14). Since then large parts of it have collapsed, gradually weakened by the harsh climate. The south transept fell in 1736, and much of the nave followed it in 1762. The central tower, no longer buttressed on its south and west sides, collapsed in 1830. The surviving edifice is worn and weathered; its maintenance represents a continuing challenge in the face of the wind and rain.

Below: View looking south-west from the choir of the abbey church across the plan of the 12th-century church, which is marked out in the grass

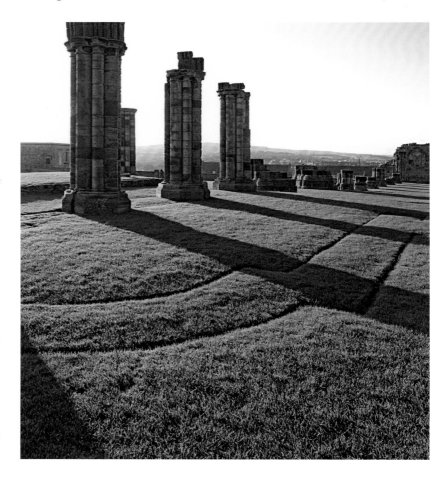

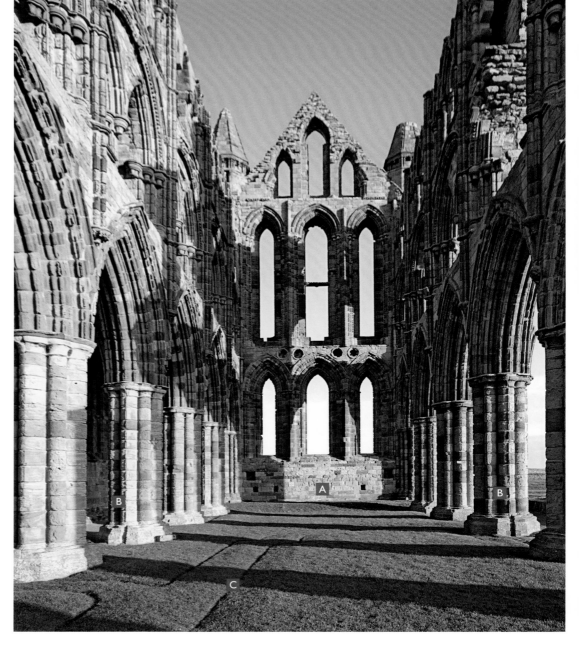

The presbytery

A Site of the high altar

B Notches – evidence for timber screens

C Plan of the 12th-century church marked out in the grass

▣ PRESBYTERY

There is no documentary evidence for the exact date when rebuilding of the abbey church began, but the style of the building – in mature 'Early English' Gothic – suggests that it was probably started in the late 1220s under Abbot Roger of Scarborough (abbot from about 1223 to 1245). It replaced an earlier Romanesque church at Whitby, which had a much shorter eastern arm or presbytery: the line of its walls is marked out in the turf. In medieval England most of the grandest

monastery churches were Benedictine houses, like Whitby. Benedictines were rich and a fashion developed, starting at Canterbury in the 1130s, for demolishing short presbyteries and building much bigger ones. It was usual, in rebuilding an 11th- or 12th-century church, to start at the east end and work westwards: later generations often went on to replace the 12th-century nave as well, as happened here.

The presbytery is seven bays long and stands to its full height: the shell is more or less complete

except for the south aisle wall. This arm of the building served as the liturgical heart of the church: it housed the choir, where the monks sat for their services, and the high altar where mass was celebrated. The interior spaces of monastery churches were divided into sections by screens. In the medieval period, the choir would have been hidden behind a stone screen between the massive crossing piers, the footings of which are still visible. The building would have been limewashed, with architectural details picked out in colour, and the windows filled with stained glass. The church was evidently not designed to have a stone vault, although its timber roof may have been designed to resemble one.

The abbey is built on rising ground, so there are steps in the first choir bay – an unusual arrangement. The columns separating the second and third arches have notches cut into their pier bases: these probably housed a timber screen spanning the main space. Behind this was the choir, where the monks assembled for their eight services a day. Further notches suggest that timber screens were also set in the fourth arches. These would have helped to enclose the choir stalls. The fifth arches were probably left open, creating a route from the aisles into the sanctuary.

It is not certain where the high altar at Whitby was. The raised level and wall-cupboards suggest that an altar stood against the east wall, although this may have been a subsidiary altar, perhaps dedicated to the Virgin Mary, mother of Christ, who was the subject of particular devotion in the Middle Ages. It was common in great English churches in this period for the high altar to be placed in front of another screen, a few bays back from the east wall; the area behind would have had a separate dedication or use. In many Benedictine monasteries, including several English cathedrals, this area housed the shrine of a saint. Whitby's church was dedicated to St Peter and St Hild, and several Anglian saints including Edwin and Hild were once buried there; however, we have no evidence that the Benedictine monks at Whitby ever possessed the bones of a saint. Indeed, the monks of Glastonbury Abbey in Somerset claimed that they had the remains of St Hild, given to them by King Edmund in 944. So the arrangement of Whitby's eastern arm remains a puzzle.

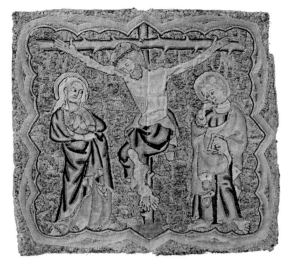

Left: This embroidered burse (a holder for the cloth used to cover the elements of the Eucharist), dating from about 1300, is thought to have come from Whitby Abbey; it depicts a scene of the Crucifixion

Below: Monks singing in a choir, from a 15th-century French manuscript

Looking towards the east
end of Whitby Abbey

A Aisle
B Triforium
C Clerestory
D Crossing pier
E North transept

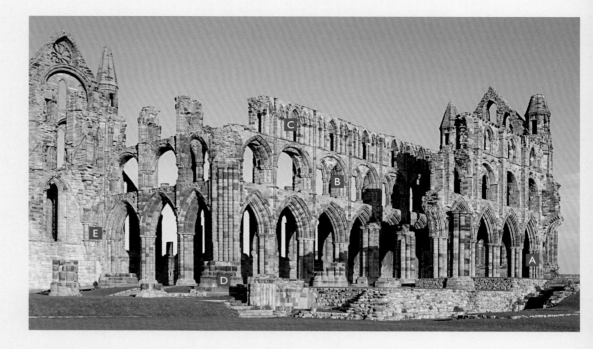

English Gothic Architecture

*The new style
became higher
and lighter, with
more elegant
proportions*

*Below: The north transept
of York Minster. The design
for the eastern arm of the
abbey church at Whitby
was probably based on the
transepts at York*

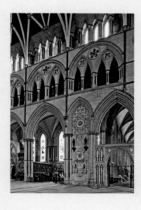

Whitby Abbey is a magnificent example of English Gothic architecture built over a long period. Its eastern arm, however, represents a fairly specific phase in the development of the style in England, between about 1220 and 1250. Gothic architecture, based on the pointed arch, originated in northern France in the mid-12th century. It evolved from the heavier Romanesque style with its thick walls, semicircular arches, and relatively small windows. In the 1140s Abbot Suger of Saint Denis, north of Paris, had a vision of a new architecture in which light represented divine truth. The new style progressively became higher and lighter, with thinner columns, larger windows, and more elegant proportions.

The style was first brought to England in the late 12th century, probably by French masons, but by 1200 English masons were making it their own. Master masons designed and ran building projects, trained apprentices, and moved from church to church. We only know a few of their names, but the 'signature' of individual masters can probably be traced in details such as the shape of columns, the moulding profiles, and the carved ornament.

The architecture at Whitby is similar in style to work at the northern monasteries of Rievaulx and Byland (both Cistercian) and Kirkham and Hexham

(Augustinian), although they are probably a little earlier. Abbot Roger, who probably commissioned the rebuilding at Whitby, may have been motivated by a spirit of competition with these and other houses. The likely source for its design, though, was the transepts of York Minster, rebuilt between about 1225 and 1255 by Archbishop Walter de Grey, and the grandest church-building project in the north of England at the time. The overall composition of Whitby's façades, inside and out, and many of the details, are simplified versions of the York transepts, and Abbot Roger may well have employed a mason from York.

Whitby's eastern arm is a fairly standard example of this style. The richly moulded arches of the aisles, with their distinctive 'clustered' columns, supported the triforium above. This was an arcaded gallery, which would have been dark as there were no windows at this level. Its arches would have been adorned and subdivided with colonettes of a dark, polished limestone or marble, which are now missing. Above this is the clerestory, with two blind arches to either side of a single-light window in each bay. The abbey church had a timber roof, probably lined with a boarded ceiling with imitation vaulting ribs as at York Minster: the structure was clearly not designed to support a stone vault.

3 TRANSEPTS AND 4 CROSSING

The transepts are the short arms in a cross-shaped church; the place where they intersect with the long axis is called the crossing. At Whitby, as at many great English churches, the crossing was capped with a square tower.

Transepts allowed for extra side-chapels with altars which could be separately dedicated. At Whitby, an eroded late medieval inscription in the north transept used to say that 'John of Brumton, sometime servant of God' dedicated an altar to the 'Blessed Mary' there. Masses could be said for the souls of patrons, who paid handsomely for this important service. More generally, transepts were used as circulation areas and gave a large church its emblematic cross shape.

At Whitby, the north transept stands to its full height and is well preserved, whereas the south transept fell in 1736. Historic views suggest that the south transept was similar in its architecture to the north transept. After the

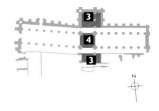

eastern arm was completed, perhaps about 1240–50, there was probably a break in the work, which was long enough, at least, for the transepts of the old Romanesque church to be taken down. At first sight the north transept's architecture is similar to that of the presbytery, but it differs in various details, such as the blind arcading on the lower part of the walls, and the rich foliate carving of the capitals. Down at floor level, remains of the transepts of the Romanesque church with their apses, excavated in the 1920s, have been partly rebuilt.

The massive crossing piers carried a short lantern tower. It collapsed on 25 June 1830, but we have good drawings of it by the artists John Buckler and his son John Chessell Buckler, which show that it was in the mature Early English style of the mid- to late 13th century. Central towers and lanterns are rare in Continental Gothic churches, and this was one of the many respects in which English masons tended to go their own way.

Below: This watercolour view by John Buckler of about 1820 shows the abbey ruins from the north-west, shortly before the collapse of the tower

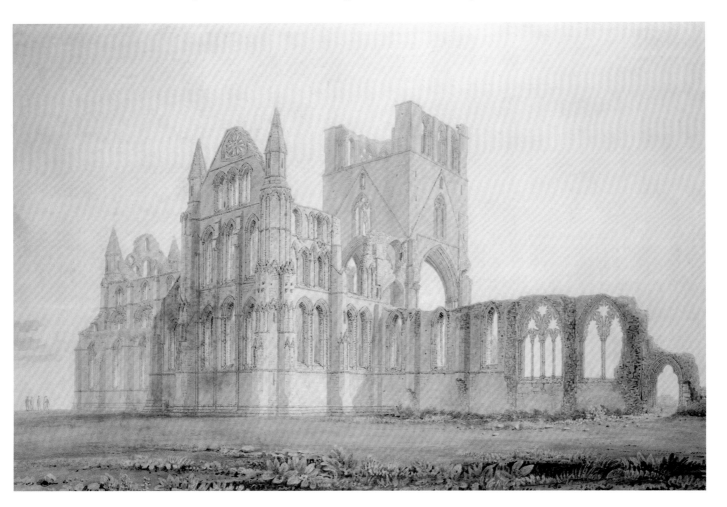

The north wall of the nave

A Late 13th-century masonry with lancet windows

B Building break between 13th- and 14th-century work

C 14th-century masonry with traceried windows

D 13th-century crossing pier

E 13th-century nave pier

F 15th-century nave piers, of different design

5 NAVE AND 6 WEST FRONT

The nave of Whitby Abbey is much more ruined than the presbytery, since much of it collapsed in 1762. Nevertheless, enough remains standing to demonstrate its scale and plan. This Gothic building replaced an earlier Romanesque nave from the early 12th century. Nothing of the latter remains visible and it has never been excavated, but there is Romanesque masonry in the doorway in the adjacent west range. This shows that the earlier nave was probably as long as the existing one, or very nearly so. The nave at Whitby is not exactly aligned with the presbytery and transepts. In fact, it is misaligned by about four degrees. There is no parallel to this in any other major English medieval church. The original 12th-century church seems to have had a slight misalignment, and in the 13th century the new presbytery was built at a slight skew to the original church. This became much more pronounced as the nave was rebuilt, perhaps because it had to fit around the cloister and its surrounding buildings.

If Whitby followed the usual plan for a Benedictine abbey church, there would have been a solid screen, known as a pulpitum, about halfway down the nave and blocking the view. Lay people could have used the western part of the nave up to the pulpitum; the area beyond was reserved for the monks. Often, the area immediately beyond the pulpitum housed the retrochoir, where old and sick monks could hear services without having to participate fully. There is no specific evidence for a pulpitum at Whitby, and indeed, no real evidence for how the nave here was meant to be used. This may seem strange when contemplating such a large building, but to the abbots and monks of Whitby their nave would have been essential to complete the traditional cross-shaped plan. The huge building was a highly visible demonstration of the piety and wealth of the abbey and its patrons.

Having built the transepts and crossing, the masons began work on the nave. The simple lancet windows in the first three bays of the north wall date to the 13th century, but only the first pair of bases for the piers of the nave arcade are of the same date: thereafter, their design changes. This shows how far the masons got in replacing the 12th-century fabric when money ran out. They would have needed at least one bay of the nave built to its new full height to buttress the central tower.

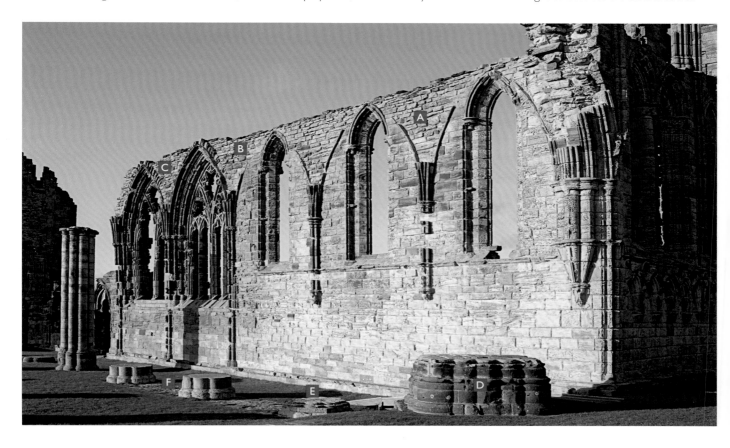

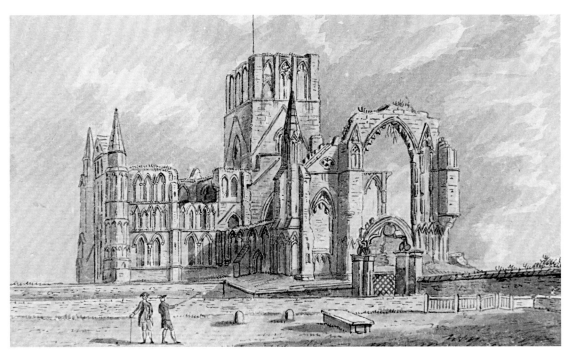

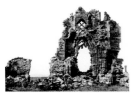

After the three lancet windows in the north wall, the style changes abruptly. The remaining five bays have much larger windows with elaborate tracery. In 1334 the archbishop of York gave John Lumby, a senior monk of Whitby, permission to raise funds to complete the church. Lumby must have had some success, for these traceried windows and the remains of the west front seem to be of mid-14th-century date. A section of the nave arcade was re-erected just north of the abbey ruins after most of the nave collapsed in 1762. This arcade, and its pier bases already noted, are in a different style again, with simpler, more angular mouldings, which shows that these elements were probably not built until the mid-15th century.

So, although there is little documentary evidence, the story would seem to be that the abbey started out on an ambitious rebuilding between about 1225 and 1230. Having completed the first nave bay and the central tower they ran out of money in the late 13th century. Between about 1334 and 1340 they raised funds and rebuilt the rest of the outer walls with the elaborate traceried windows, but ran out of money again, leaving the Romanesque arcades down the centre of the nave still standing. About 100 years later they managed to rebuild the nave arcades, and finally completed the nave. The Gothic church probably took about 250 years to complete.

The remains of the west front are in a battered and weathered condition: the shell seems to be 14th-century, but the window tracery looks to be of mid-15th-century date. On 16 December 1914, a force of German cruisers bombarded the town, severely damaging the west front. The Ministry of Works rebuilt it, using the historic masonry, in the 1920s.

Above left: This engraving of the abbey from the west, made by Francis Grose in about 1790, shows the church before the collapse of the central tower and the west front
Above: A series of photographs taken in 1914 showing the final collapse of the west front after the German bombardment. The façade was later rebuilt
Left: A donor giving a bag of money to St Albans Abbey, from a late 14th-century catalogue of the benefactors of St Albans. At Whitby the monks managed to raise enough funds in the 1330s to continue work on the nave

Right: Scholars in a library, depicted in a 15th-century French manuscript. An inventory of the library at Whitby Abbey listed 87 volumes

Below: North view of Whitby Abbey, drawn by P Combes and engraved by Samuel Buck in 1711. By this date the monastic buildings around the cloister had already been demolished

7 MONASTIC BUILDINGS

To the south of the abbey church was a large complex of monastic buildings around a cloister, but these have almost completely disappeared. They had already gone by the time the earliest known view of the site was engraved by Samuel Buck in 1711. The Cholmley family must have demolished them for building materials in the 16th and 17th centuries.

The buildings undoubtedly followed a classic monastic layout, around a square cloister, and this seems to be borne out by evidence from ground-penetrating radar surveys. All that remains visible are some of the footings of the west range, which probably housed storage and service rooms. These remains were cut back in the 1670s when the ground nearby was lowered and a massive retaining wall built, to form the entrance courtyard to the Cholmleys' house. The area of stonework next to the abbey church was probably the outer

parlour, where the monks could receive guests. The mouldings of the broad doorway here are Romanesque, probably of the early 12th century.

In the north-east corner of the cloister area there are remains of a doorway with steps up into the abbey church. The broad stone recess just south of this was probably a book cupboard, which housed the hymnals and psalters used for divine service. An inventory of the abbey's library lists 87 volumes, which were probably kept separately. It was a fairly standard collection, dominated by copies of scripture, commentaries and other theological works. There were many lives of saints, and a comprehensive collection of the works of Bede including his *Ecclesiastical History*.

Just south of the book cupboard are the remains of a stone passageway beneath the south transept, again of 12th-century masonry. South of this was the chapter house, where the monks gathered each day, business was transacted and punishments were meted out. Nothing of it remains standing, but one side can be seen in Samuel Buck's engraving. The monks' dormitory probably occupied the upper floor of this range. On the south side of the cloister, which is now an open space, would have been the refectory, where the monks ate their two meals a day in silence; the warming house, the one place where they were permitted to enjoy a fire; and the kitchen. Further south were other buildings, probably including the monks' infirmary. The guest house was probably to the west, nearer the abbey's main gate.

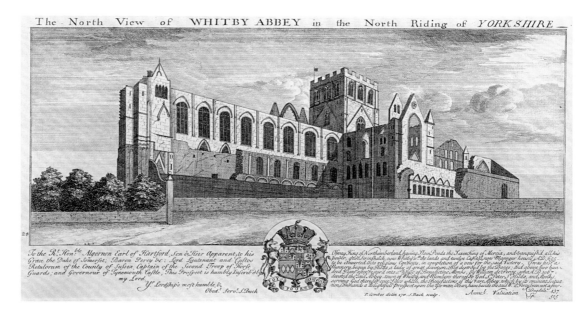

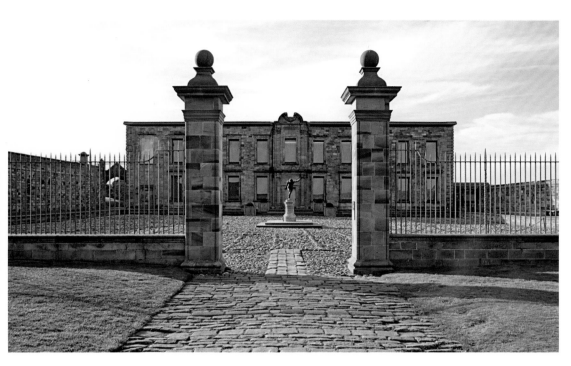

8 ABBEY HOUSE

To the south-west of the abbey church stands a major group of buildings. This was formerly a residence of the Cholmley family, who acquired the abbey and its estates in 1540, shortly after the Suppression of the Monasteries, and owned it until the 20th century. The buildings are in two parts to either side of a courtyard. At the back is a much altered medieval building with a substantial Victorian wing. At the front, facing north, is a grand classical wing built in the later 17th century.

The abbot's lodging probably stood here, and after 1540 the Cholmleys adapted it as a residence. The main gatehouse (now vanished, but probably somewhere near the west front of the abbey church) was used as a secondary residence. In the early 17th century, Sir Hugh Cholmley I (1600–57) remodelled the medieval buildings here, probably forming a compact courtyard residence approached from the north.

In about 1670–72 Sir Hugh Cholmley II (1632–89) built a grand new north wing, which may incorporate masonry from an earlier building on the site. It was ready for use by March 1674, when the house was prepared to receive a party with 25 horses. It was built on the 'double-pile' plan, two rooms deep with a central spine wall, which was fashionable in the mid-17th century. Most double-pile houses were new, detached residences, but at Whitby the older wing was retained to house the kitchens and service rooms.

Sir Hugh Cholmley II's new wing is a stately piece of late 17th-century classical architecture in a tradition of house design known as 'Mannerism' that had been developing in England since the 1630s. The architect is unknown, but Sir Hugh had experience of major engineering projects (see below, page 32), and he may have designed the wing himself. There is a single reference to a mason called Longstaffe or Langstaffe, probably the John Longstaffe (1649–1719) who settled in Whitby, although it may have been his father. There are some curious irregularities in the architectural details, which could arise either from the stonework having been reused from an earlier building, or from later repairs. The architectural impact of the façade has been much reduced by the loss of its pitched roof and the original cross-bar glazing. Around the corner, the façade changes in character, with offset windows and prominent pediments above them. This suggests that it might have been designed by Sir Hugh himself, who, as an amateur, was more preoccupied with including fashionable architectural features than in achieving a consistent design.

The family abandoned the house in the 18th century, and in 1790 the new wing's roof was blown off in a gale. Its plan cannot be

Above: The forecourt and north wing of Whitby Abbey House. Completed in 1672 for Sir Hugh Cholmley II, this grand façade gave a completely new aspect to the house (see page 31)

The Whitby *Gladiator*

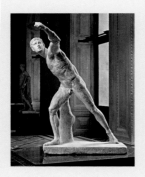

In 1682 a historian referred to a 'curious figure in solid brass as large as life in the midst of the square' at Sir Hugh's house

In 2009 English Heritage unveiled a newly made lifesize bronze figure of a Roman gladiator, lunging with a sword, in front of the north wing of Whitby Abbey House. This is a copy of a famous ancient statue now in the Musée du Louvre, discovered in the early 17th century and named the Borghese *Gladiator* after its first owners, a noble Roman family. Its placing here recreates an important element of Sir Hugh Cholmley II's work at Whitby.

Sir Hugh (1632–89) created an impressive pair of entrance courtyards to the north of his new wing. These were long covered in grass, but archaeological excavations in 1998–9 revealed that the inner court had a rough layer of cobbles, with an irregular pattern formed by lines of larger stones. This is something of a puzzle, as this surface could not possibly have been crossed by horses or carriages: it may be that the cobbles were meant to show as a pattern through a surface of something like gravel or lime concrete. In the middle of the cobbles the excavation revealed the foundations of a broad, stepped platform.

In 1682 the Yorkshire historian, Ralph Thoresby, referred to a 'curious figure in solid brass as large as life in the midst of the square' at Sir Hugh's house. Research has identified this as a copy of the Borghese *Gladiator*, which was known in England from a copy made for King Charles I by the French sculptor Hubert le Sueur, now at Windsor Castle. As an officer of the royal household Hugh Cholmley II would have known it well, and his gladiator may have been cast from this version. Several more copies were cast in lead in the 18th century, and versions survive elsewhere, including at Burton Agnes Hall and Castle Howard, both in Yorkshire. We do not know what happened to the original Whitby *Gladiator*, which disappeared from here some time in the 18th century.

A fine stone pedestal, set into the retaining wall which overlooks the courtyard, was recognized as having probably been the *Gladiator*'s original plinth: this provided the last piece of the jigsaw. So in 2008–9, to recreate Sir Hugh's scheme, the steps and plinth were rebuilt in new stonework, and a fine bronze copy of the Windsor *Gladiator* was made and installed. Sir Hugh's courtyard once more has a focal point.

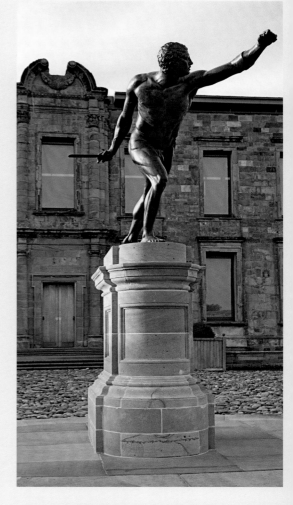

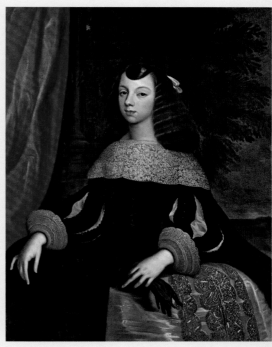

Above: The original Borghese Gladiator, *which dates from the first century* BC, *in the Louvre, Paris*

Above right: The new Whitby Gladiator, *cast in 2008–9, is a copy of the 17th-century version of the gladiator at Windsor Castle*

Right: Catherine of Braganza, *Charles II's queen, by or after Dirk Stoop, about 1660–61. Sir Hugh Cholmley II was a groom of the bedchamber to the queen, and as an officer of the royal household would have been familiar with the copy of the gladiator at Windsor*

reconstructed in detail, but the spine wall remains, with evidence of fireplaces and doorways. If the wing followed the usual planning principles of the 1670s it would have had a central entrance hall, with a large staircase opening off it and a grand reception room or 'saloon' above. There would have been suites of more private rooms, each with a drawing room, bedchamber and dressing room, to either side. English Heritage has recently reroofed the wing and fitted it out using modern materials, to designs by the architects Stanton Williams, to house a shop and exhibition.

Behind this wing is a courtyard, the heart of the Cholmleys' house: the fragments of masonry to the east of the courtyard are remains of their chapel. The older wing on the south side of the courtyard is medieval in origin. It was probably part of the abbot's lodging, but was much altered by the Cholmleys: its windows date from the early 17th century and from the 1670s. It probably housed their great hall at first-floor level. The section of projecting masonry carried on corbels on the outer (south) side of this wing may represent the hall fireplace.

The Victorian wing was added in 1866 by Sir Charles Strickland to make it a summer residence. It now houses a youth hostel, and is occasionally open to the public. The wing has numerous interesting features, including broad medieval

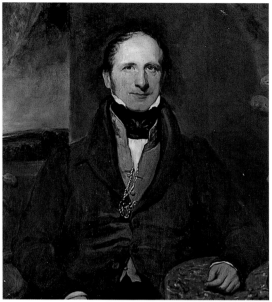

fireplaces, a 17th-century staircase, a room with early Georgian panelling, and a fine Victorian main staircase. There are other old features, which have probably been reused from elsewhere on the site, notably a huge oak beam carved with figures of animals and men, found built into a wall during recent building works. The heavy door near the visitors' lavatories with its distinctive long hinges is probably of 12th- or 13th-century date, and is another survival from the monastic past.

Left: Portrait by H Smith of Sir George Strickland (d.1874), who inherited the Cholmleys' Whitby estates in 1857
Below: The east wing of Abbey House, added by Sir Charles Strickland (Sir George's son) in about 1866 to provide a summer residence

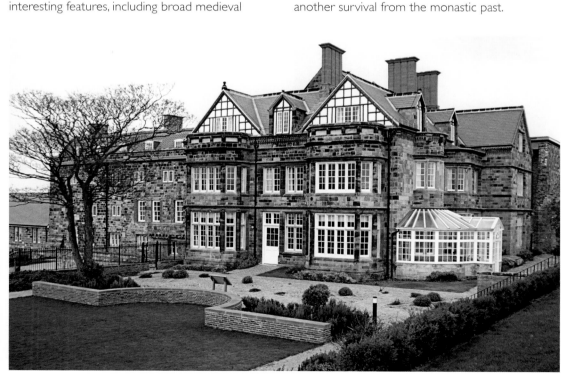

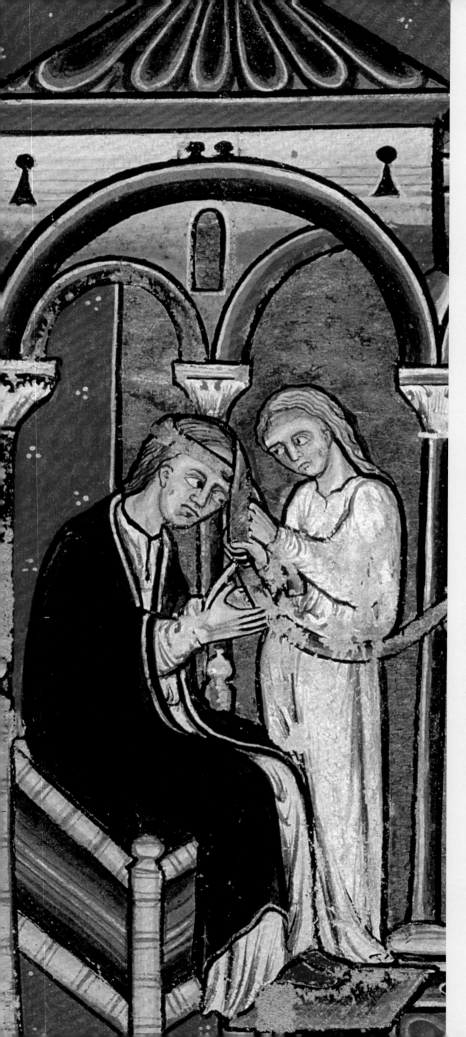

History

A monastery was first established at Whitby in AD 657 by Oswiu, king of Northumbria. It became one of the most important religious centres in the Anglo-Saxon world, under the rule of Abbess Hild, and it was here that the great synod of Whitby, which determined the future direction of the church in England, was held in 664.

In the ninth century this monastery was abandoned, probably following Viking raids, but after the Norman Conquest a new community was established on the site by a Benedictine monk, Reinfrid. This foundation eventually grew into one of the richest monasteries in Yorkshire.

The abbey was suppressed by Henry VIII in 1539, and shortly afterwards the buildings were bought by a prominent local family, the Cholmleys. They took over the abbot's lodging as a house, which was remodelled in the 1670s with a grand new wing. Parts of this house remain in use today.

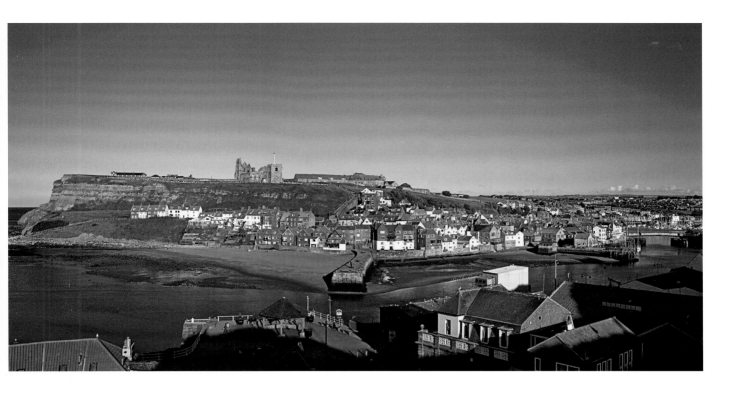

THE PREHISTORIC PAST

The North Yorkshire coast is a famous hunting ground for fossils from the Lower and Middle Jurassic periods, between 200 million and 145 million years ago. This area was then on the bed of a warm, tropical sea. The remains of vast numbers of sea creatures, including marine reptiles such as plesiosaurs and ichthyosaurs, became fossilized in the seabed. As sea-levels changed over millions of years, the seabed became dry land, and was then eroded into cliffs by the North Sea. In modern times (the Holocene period), erosion exposes more fossils in these cliff faces every year. They began attracting serious scholarly interest in the early 19th century, and Whitby Museum has a superb collection of fossils, including

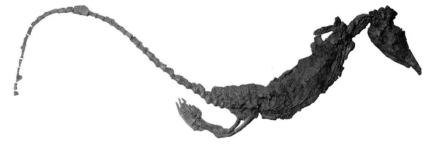

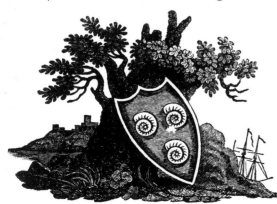

prehistoric marine crocodiles and giant ammonites (prehistoric sea creatures).

Signs of Neolithic and Bronze Age occupation have been found in the Whitby area, but impressions of timber post-holes from Iron Age houses provide the earliest positive evidence for settlement on the headland. No trace of Roman buildings has been discovered, but numerous finds, including fine imported pottery, show that people lived here then. It is probable that a Roman signal station stood on the headland, one of a series built along the Yorkshire coast in the third century, to keep watch for pirates. Whitby is midway between the sites of known signal stations at Goldsborough and Ravenscar: out of sight of each other, they would have been linked by a station on the headland here. The signal station would have stood on the lost part of the headland that fell into the sea many centuries ago.

Top: The abbey and headland
Above: Fossil of a marine crocodile, now in Whitby Museum
Left: Three ammonites on Whitby's coat of arms, from George Young's History of Whitby, and Streoneshalh [sic] Abbey (1817). These fossils, commonly found at Whitby, were once known as snake stones, due to a legend that Abbess Hild had turned snakes into stones
Facing page: The curing of Abbess Ælfflæd by St Cuthbert, from a late 12th-century manuscript. Ælfflæd succeeded Hild as abbess in 680

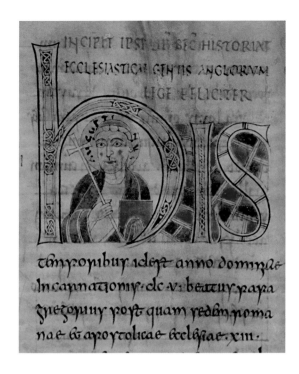

THE ANGLIAN TOWN AND MONASTERY

The name Whitby is Danish, and was given to this place by Viking settlers in the ninth century. Before that the headland was called Streaneshalch. The great eighth-century historian, Bede, translates this as 'the Bay of the Beacon', but neither half of the name can be interpreted to mean either 'bay' or 'beacon'. 'Halc' probably means a headland, while 'Streane' may be a personal name: 'Streane's headland' would be a more literal translation.

Streaneshalch occupies an important place in the history of England. In the fifth and sixth centuries, Anglo-Saxon people from northern Europe settled in Britain. The Angles settled in the north and east, while the Saxons settled in the south and west. In the north, Anglian settlers founded two kingdoms: Deira, represented by modern Yorkshire, and Bernicia, which covered Durham and Northumberland and stretched into lowland Scotland. In the seventh century the two were united to form the kingdom of Northumbria.

Until the sixth century the Anglo-Saxons were pagans, worshipping gods such as Woden, Tiw and Freya (similar deities with these names were worshipped by other northern people, such as the Vikings). Their subsequent conversion to Christianity came via two different routes. The first originated in Rome, from where Pope Gregory the Great sent Augustine (d.604) on a mission to England in AD 597. Augustine landed in Kent, where he converted King Æthelberht of Kent (about 560–616) and his people. Augustine's followers spread out, among them Paulinus (d.640). He reached Northumbria in 627, converted King Edwin (d.633), and baptized him and his household.

Meanwhile, Christianity was being brought to England via another route, by Celtic missionaries from Ireland. They first converted the inhabitants of Scotland, and then moved south. The Celtic tradition was relatively isolated, and had little contact with the centralizing power of Rome as represented by Augustine. The rivalry between these two different strands of Christianity was eventually to come to a head at Whitby.

The conversion of the peoples of Britain did not proceed at all smoothly: many of them resisted the new faith and fought against it. Following a series of mid-seventh-century battles between the Christian kings of Northumbria and pagan rulers from elsewhere in Britain, Oswiu of Northumbria (d.670) finally defeated the forces of paganism led by Penda of Mercia at the battle of the Winwaed in 655. The Christian faith in Britain was saved, and the fate of paganism sealed. Oswiu became king of Northumbria and married King Edwin's daughter, Eanflæd. The minster at Whitby – or Streaneshalch – was founded in the aftermath of this victory.

The Foundation of the Minster

To honour a vow made before the battle, Oswiu gave his infant daughter Ælfflæd to be a nun at Hartlepool, 30 miles up the coast. It was ruled by a remarkable abbess, Hild. Hild was born in 614; her father, Hereric, was a nephew of King Edwin. She was brought up at Edwin's court, and was probably baptized by Paulinus in 627. In 657 Hild founded a new minster for men and women at Whitby, with King Oswiu's support. It was endowed with 12 hides of land (a hide was as much land as one plough-team could plough, approximately 485ha), and it became the main royal minster of Northumbria, its principal church, dedicated to St Peter, being the royal burial place. Abbess Hild's peaceable rule set the tone for the community: her fame spread, and kings and commoners alike sought her advice. Five monks of the house became bishops in her time, including John of Beverley, bishop of Hexham, and Wilfrid.

THE SYNOD OF WHITBY

The height of the minster's fame came with the great synod of Whitby in 664. Until then, the Celtic missionaries had been predominant in Northumbria. However, missionaries from Rome were arriving, and Queen Eanflæd had a Kentish-trained priest named Romanus in her household. The Celtic and Roman traditions differed in many respects, such as their clothing and the way they wore their hair, but the most important difference was in the calculation of the date of Easter. This led to great confusion, and in some places Easter was celebrated twice as a result. Given the newness of Christianity in England and the supreme importance of Easter, this situation could not be allowed to continue. So a synod was held at Whitby to resolve the matter, and Oswiu and his court attended it.

Bishop Colman of Lindisfarne (d.676) led the Celtic side, while the Roman point of view was led by Wilfrid (d.709), a monk of Whitby who had founded a new church at Ripon, and later became bishop of York. The two sides disputed, claiming authority from the Apostle John and from St Peter respectively. Wilfrid closed the argument by pointing out that Rome owed its authority to St Peter, and that the keys of the kingdom of heaven had been given to him. King Oswiu then asked if this statement was true, and both sides agreed that it was. The king asked if St Columba, founder of the Celtic Church in Scotland and northern England, had a similar authority, and Colman admitted that he did not. Oswiu concluded: 'Peter is the guardian of the gates of heaven, and I will not contradict him. I shall obey his commands in everything … otherwise, when I come to the gates of heaven, there may be no one to open them, because he who holds the keys has turned away.'

Hild died in 680 at the age of 66, and was buried at Whitby. She was succeeded as abbess by Oswiu's daughter Ælfflæd, who ruled jointly with her widowed mother Eanflæd.

After this Streaneshalch and the minster disappear from the historical record. Early in the ninth century, Viking raiders from Denmark began to attack the coast of England. They were pagans, and they burnt and sacked the Northumbrian minsters. Hence, it is assumed that Hild's minster

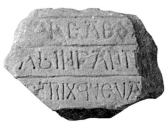

Above: Fragment of an Anglian grave marker found at Whitby. The letters LEAEd in the first line are believed to be part of Abbess Ælfflæd's name, and the stone may have marked her grave

Below left: A monk with a Celtic-style haircut, from the seventh-century Book of Durrow

Below: A 13th-century depiction of a monk receiving a Roman-style haircut

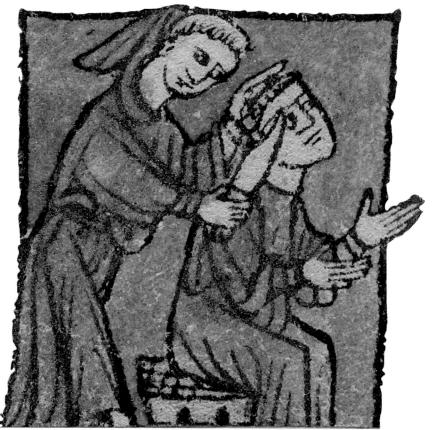

Above: A grave marker found at Lindisfarne, thought to be Danish, and carved with seven men brandishing weapons

had been destroyed by the end of the ninth century. A 12th-century chronicle claimed that a later English king, Edmund (r. 939–46), had given the remains of St Hild to Glastonbury Abbey in 944: we have no way of knowing if this could be true but it demonstrates that Hild's legend had lived on, largely thanks to Bede's *History*.

The Danes did not just come to raid: they settled in large numbers along the whole eastern seaboard of England north of the Thames. They left virtually no written records, and almost the only way to establish where they settled is from place-names. The commonest form of Danish place-name ends with '-by', and there is a large group of these names in the area around Whitby. Whitby's history in the 10th and 11th centuries is totally obscure, but in the Domesday survey of 1086 it was said to pay taxes worth £112, making it the most important place in the neighbourhood. So Danish Whitby developed down by the harbour as a small but prosperous fishing port. Meanwhile, both the archaeological evidence and

the documentary records tell us that the site of Anglian Streaneshalch, up on the headland, was ruined and abandoned.

REINFRID AND THE REFOUNDATION OF WHITBY ABBEY

The foundation of the second monastery at Whitby happened in the aftermath of the Norman Conquest of 1066. The north of England put up serious resistance to the new regime and the result was a devastating onslaught, the 'Harrying of the North', with hundreds of villages burnt and great numbers of English rebels put to death. William the Conqueror (r. 1066–87) divided land in the north among his close followers, one of the most important being William de Percy. He was given land in Yorkshire and Lincolnshire, including Whitby, which he held as a tenant of the earl of Chester.

The accounts of how the new Whitby Abbey was founded are confused and sometimes contradictory. The most reliable account is probably in the monastery's cartulary (a volume

Caedmon, who lived at Streaneshalch, could listen to a scriptural story and turn it into verse

Right: A page from an 11th-century manuscript of Bede's Ecclesiastical History of the English People. A few lines of Caedmon's hymn have been added at the bottom, in a different colour

Caedmon

In about 680 a layman called Caedmon lived at Streaneshalch. He had no aptitude for music, until one night, in a dream, a man called on him to sing. 'I do not know what to sing', he replied, and the man asked him to sing of the Creation. Caedmon immediately began singing, and in the morning he could remember the whole song. News of his talent soon spread and he was taken to Abbess Hild, who recognized that he had received divine grace. Caedmon, the first named poet in the English language, could now listen to a scriptural story and turn it into verse. Just one fragment remains of his work, one of the oldest pieces of Old English verse. Translated into modern English, it reads:

Praise we the fashioner now of Heaven's fabric,
The majesty of his might and his mind's wisdom,
Work of the world-warden, worker of
 all wonders,
How he the Lord of Glory everlasting
Wrought first for the race of men Heaven as a
 roof-tree,
Then made he Middle Earth to be their mansion.

listing the donations made to the abbey), which tells how a Norman soldier called Reinfrid, one of the Conqueror's companions at the battle of Hastings, was travelling in the north in the 1070s. When he visited the ruins of Hild's monastery on the headland at Whitby, he was so moved by the scene of desolation that, on his return south, he became a monk at Evesham Abbey.

Reinfrid returned north with two English monks, Aldwine and Elwine, to revive the monastic tradition there. They settled in the ruins of Bede's old monastery at Jarrow, where Aldwine became the abbot of a revived house. After a while, Reinfrid returned to Whitby to live as a hermit. By 1078 he had gathered a number of followers and founded a priory of monks there, in the ruins of the Anglian monastery, which William de Percy gave to them.

At this point the accounts become confused and it is impossible to be certain of the truth: what follows is an interpretation. It seems that two influential individuals joined the new house, one called Stephen, and the other called Serlo de Percy, brother of the benefactor William. There was a dispute over the direction of the community: Reinfrid wanted it to remain a modest and isolated group, living very simply. Stephen wanted to develop a Benedictine community ruled by an abbot, something much more structured and potentially much bigger and grander. The community split, and Stephen and a group of rebels moved to Lastingham. Reinfrid and the remaining monks were forced, by the threat of raiders from the sea, to leave Whitby as well, and moved a few miles to Hackness. Reinfrid died, and Serlo de Percy took over the community at Hackness.

Stephen and the breakaway community were destined for greatness, for they attracted the support of Alan the Red, earl of Richmond, who gave them the church of St Olave in the city of York. Alan the Red was a favourite with the new king, William Rufus, who visited York in 1088. He too liked the idea of having a Benedictine monastery in York, but did not think that St Olave's was grand enough. So the king gave the monks a larger site and laid the foundation stone of a new monastery – St Mary's Abbey at York, which eventually became the richest monastery in northern England.

Meanwhile the pirate threat had receded, and Serlo de Percy and the remaining monks at Hackness moved back to the headland at Whitby. Serlo maintained Reinfrid's original 'eremitic' vision, but his brother William seems to have decided that he, too, wanted the prestige of having a proper Benedictine monastery under his patronage. Serlo seems to have retired or been forced out. Whitby adopted the Benedictine rule, and became a full abbey with William de Percy's son, another William, as its first abbot. William senior gave the new abbey much more property, including the town of Whitby. All this seems to have happened between the time of the Domesday survey in 1086 and 1096, when William senior went on the first crusade to the Holy Land, where he died in Jerusalem.

Above: Anglian gaming pieces, made of jet, excavated at Whitby Abbey
Below: Vikings disembarking in England, from a 12th-century English manuscript

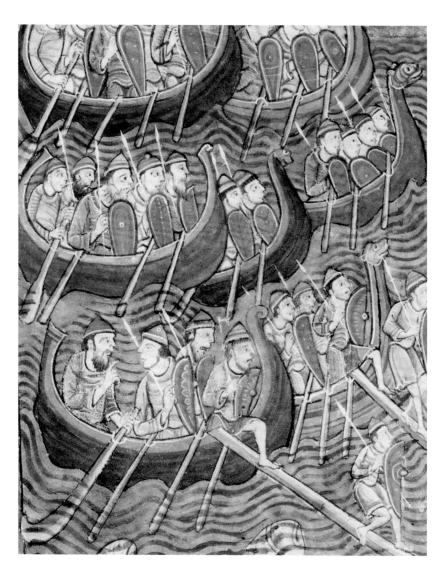

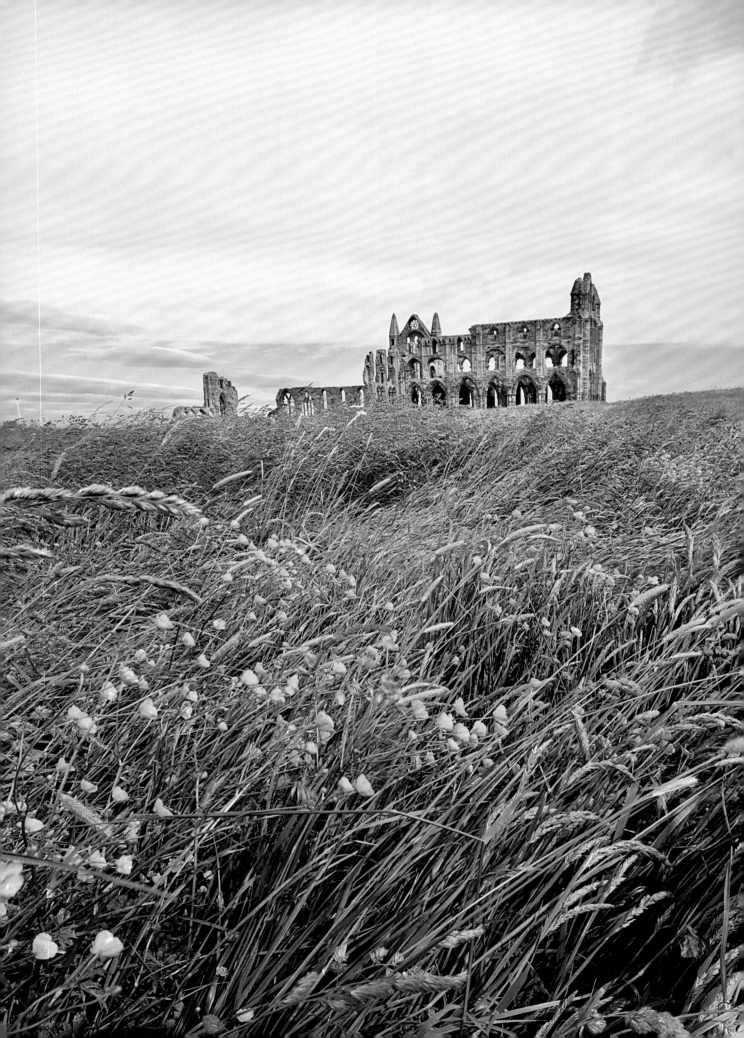

THE BENEDICTINE ABBEY

The Percy family continued to be Whitby Abbey's main supporters, though there were others. In the first half of the 12th century grants of land and property in Yorkshire, Lincolnshire and Westmorland came thick and fast, but thereafter they seem to have slackened off. The Percys' support allowed for Whitby's first stone buildings to be built in the Romanesque style, probably from about 1109. Only traces of them remain visible (see pages 7–8 and 14). The first documentary evidence of building activity is a reference to Abbot Richard I (1148–75) being buried in the chapter house which he had built.

A Benedictine monastery was divided between novices or new monks and the full choir monks, who were required to sing and recite the divine offices. Some of the choir monks also had important roles within the monastery, such as the cellarer, who looked after supplies of beer and wine, and the almoner, who managed the distribution of food and alms to the poor.

St Benedict's rules, which governed the monks' lives, were strict. The monks wore a coarse black habit day and night, with an apron called a scapular over it. Meals were taken twice a day in the refectory in silence, accompanied by readings. Only invalids were allowed meat. The monks were not allowed any private possessions, and owed absolute obedience to the abbot; they could not leave the monastery except by permission of the abbot or prior. The monks' lives were given up to prayer and contemplation, and were dominated by the divine offices or 'Work of God': eight services of prayer, psalms, and hymns a day, called Matins, Lauds, Prime, Terce, Sext, Nones, Vespers and Compline. There was also a daily Mass.

Our knowledge of the abbey's history is patchy, as it is almost all based on one surviving book, the abbey's cartulary. This compilation of documents mainly relates to grants of property or legal privileges, but occasionally provides historical narrative. There were tribulations in the mid-12th century: Abbot Benedict was dismissed for squandering the abbey's resources in 1148, and a Norse raid took place in about 1153. A document of 1148 lists 38 monks, all of whom are named. Rather surprisingly, they all seem to have been of Norman origin: there is not a single English name in the list.

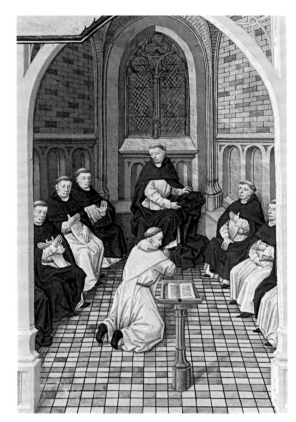

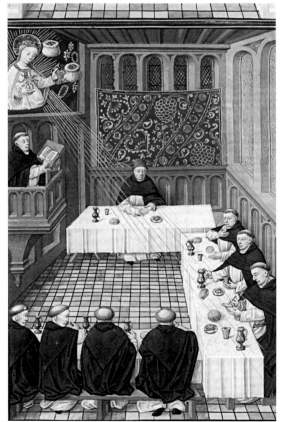

Above: An architectural ornament in the form of a bishop's head, and a 13th- or 14th-century floor tile bearing the words 'Ave Maria' (Hail Mary). Both objects were excavated at Whitby Abbey

Above left: Monks in a chapter house, from a 15th-century Flemish manuscript. The monks met here daily to conduct abbey business and hear a chapter of their order's monastic Rule

Left: Monks dining in a refectory, from the same 15th-century manuscript. The abbot sits at a separate table, and a monk reads from a pulpit while everyone else eats in silence

Facing page: The abbey ruins seen from the south

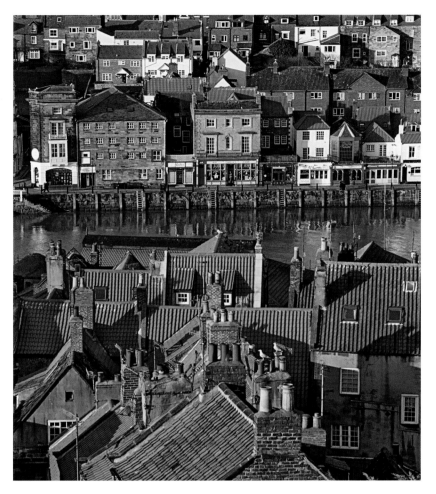

Above: The harbour and town
Right: The steps leading up to the East Cliff and the parish church

THE ABBEY AND THE TOWN

When William de Percy re-established the abbey in about 1090, one of the grants of property that he made to it was the lordship of the town of Whitby. Before the Norman Conquest it had been a thriving little town, but it had been devastated during William the Conqueror's 'Harrying of the North' in 1069–70: the Domesday survey of 1086 recorded that the manor was all 'waste', meaning uninhabited, apart from a few villagers maintaining one plough up on the headland. Nevertheless, the community must have been recovering, for within about 20 years the monks had ordered the construction of the large stone parish church which still stands.

The medieval town grew up on both sides of the harbour. It is not known why the church stands so high above the town, at the top of the famous 199 steps. It is unlikely that a town of this size would have had no church previously, and the 12th-century building may be on the site of a previous one. This may be the reason why the headland is called 'Prestby' (the priest's settlement) in the Domesday survey, but it does not tell us why the church stood so high above the town in the first place, rather than at its heart.

The abbey's relations with the town were often rather strained. Henry I (r. 1100–35) gave the abbey the 'burgage' of the town, that is, the right to administer it and collect the dues and customs. Abbot Richard de Waterville (1177–89) gave the burgage to the townspeople. Succeeding abbots regretted his generosity and tried hard to get the grant reversed, eventually winning their case in 1351. After that, the town had little independence: all the profits of the town's market, its annual fairs, its merchant court and civil court, belonged to the abbots. The dispute rumbled on: in 1386 the townspeople submitted another legal challenge to the judgment of Henry de Percy, earl of Northumberland. The earl found that the abbey had 'full lordship', and most of the points went their way. The abbey could charge fourpence a plank for 'plankage' (the right to put planks down from unloading ships) for strangers, though the townspeople were exempt from this. The abbot controlled anchorage in the harbour, and could even levy a fine on townspeople who remarried.

The abbey also had a stake in the town's fishing industry, as is shown by an agreement signed by the abbey in about 1200 to send 2,000 herrings a year to Thornton Dale. From the evidence of the court cases, the relationship between town and abbey was not a happy one.

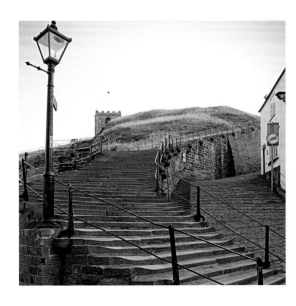

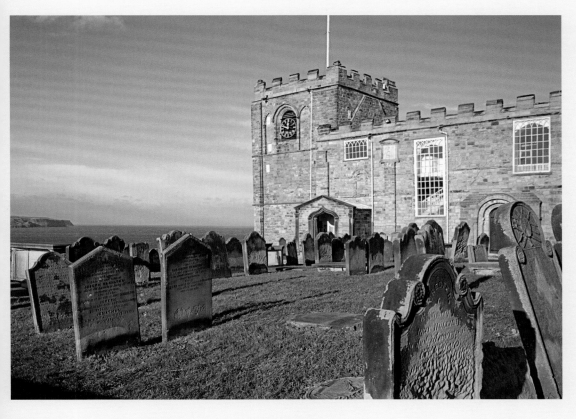

Left: *The nave and tower of St Mary's Church, Whitby*
Below: *The interior of the nave*

St Mary's Church, Whitby

Just down the headland from the abbey ruins, and close to the western entrance gate, is Whitby's magnificent parish church in its large and evocative churchyard. It stands well above the town, at the head of a celebrated flight of 199 steps. No one knows why the church is so oddly, though spectacularly, sited.

Its precise date is unknown, but the architectural details suggest that it was built in the early 12th century. The church belonged to the abbey, which almost certainly initiated its rebuilding. In its first form the church had a chancel and a slightly wider and longer nave. The tower seems to have been added later in the 12th century, and the transepts were added later again.

The exterior has some prominent Georgian alterations, including the porch and the big windows with 'Gothick' sash-lights. But what makes the church truly memorable, indeed unique, is the extraordinary interior, which is almost filled with 17th- and 18th-century box pews and galleries of labyrinthine complexity. The Cholmley family rather impudently built their gallery-pew, with its

barley-sugar columns and parapet, right across the chancel arch, blocking the view towards the altar. The architectural historian Sir Nikolaus Pevsner, writing in his monumental *Buildings of England* series, described this 'incomparable' interior as 'hard to believe and impossible not to love'.

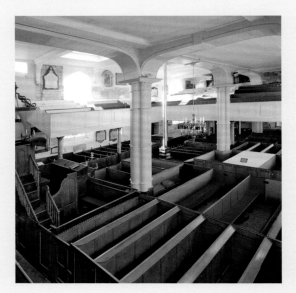

What makes the church truly memorable is the extraordinary interior, almost filled with box pews and galleries of labyrinthine complexity

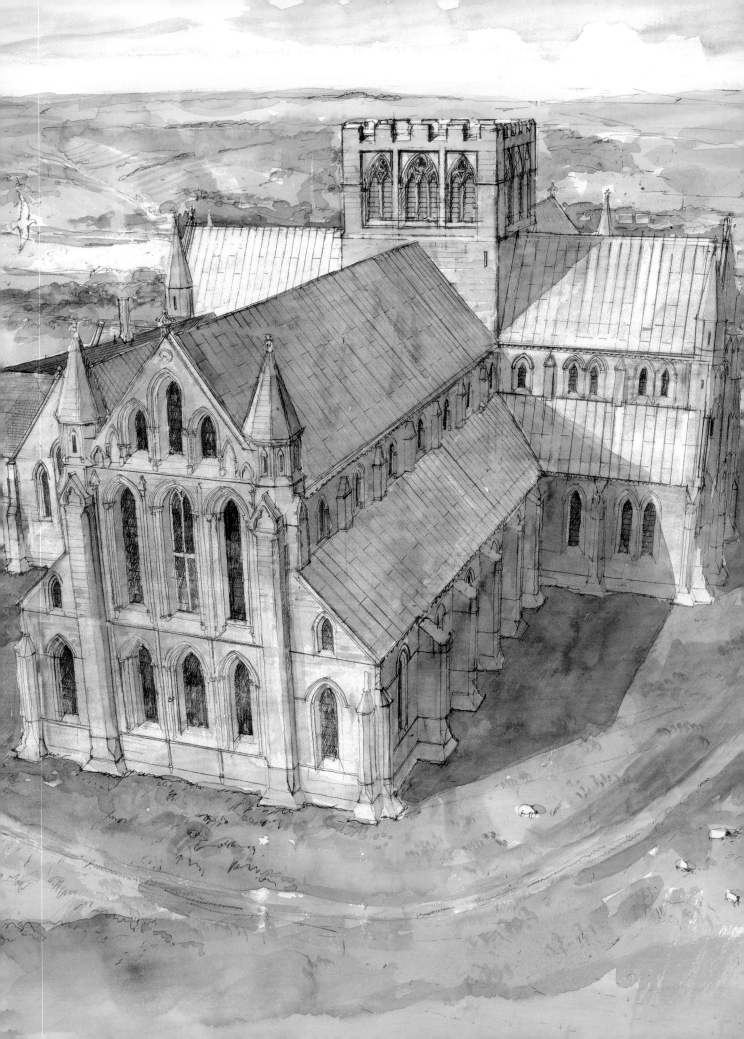

LATER HISTORY OF THE ABBEY

In the 13th century the flow of donations to the abbey slowed, though it never completely stopped. The Percys remained patrons of the house, but seem to have transferred their main interest elsewhere, and Whitby was outstripped in the competition for patronage by other monasteries, above all by its 'sister' house of St Mary's, York.

Nevertheless, some time in the 1220s Abbot Roger of Scarborough took the momentous decision to rebuild the abbey church. It appears that the building campaign overstrained the abbey's resources: the money seems to have run out in the later 13th century, and it was over 200 years before the rebuilding of the church was completed. By contrast, St Mary's in York completely replaced its Romanesque church in only 24 years, between about 1270 and 1294.

Whitby, like much of northern England, suffered from Scots invasions in the aftermath of the disastrous English defeat at Bannockburn in 1314; in 1323 the monks appealed to the Pope for help. A disciplinary visitation in 1320 shows that the abbey was burdened with debt and the monks were becoming slack, spending their time hunting: they were forbidden to keep hounds, or hunt with bow and arrows.

Despite the financial problems, the community did embark on a campaign to rebuild the nave in the 1330s. The fact that this stalled, and the nave was only finished in the 15th century, shows how far their ambitions had outrun their means. The monks were still attracting the patronage of rich families, though: in about 1480 William Tod, a merchant of Scarborough, contributed 264 shillings and 4 pence towards a chapel at Whitby dedicated to the Archangel Gabriel (at a time when a skilled craftsman might earn between fourpence and sixpence a day), and in 1483 his widow Margaret was paying the monks in silver and cloth to pray for his soul.

The last abbot of Whitby, Henry Davell, surrendered the monastery to King Henry VIII's commissioners on 14 December 1539. At the time there were 22 members of the community, and the annual revenues from the monastic estates were £437 2s 9d. This made Whitby one of the poorer of the Benedictine houses in England, although it was still richer than most monasteries of other orders.

Left: A reconstruction of Whitby Abbey as it may have appeared in about 1500, looking west. By this date the rebuilding of the church, begun in the 1220s, was finally complete

Below: A monk with a hunting hound, from a 15th-century manuscript of Chaucer's Canterbury Tales. The monks at Whitby were disciplined in 1320 and forbidden to hunt

THE CHOLMLEYS AT WHITBY

Shortly after Whitby's suppression, Sir Richard Cholmley, known as the 'Black Knight of the North', leased the site of the abbey, in 1540–41. He was the grandson of a rich yeoman farmer from near Nantwich in Cheshire. His uncle, another Sir Richard, had risen in royal service to become lieutenant of the Tower of London from 1513 to 1520, and constable of Pickering Castle with the Black Knight's father, Roger. They bought land in the area, and when Sir Richard inherited the estate, he took the family to a new level of wealth and eminence: he had 50 or 60 servants, and when travelling had a retinue of 30 or 40. He bought the freehold to the abbey land in 1555, and subsequently bought further parts of the abbey estates. By the time he died in 1583 he owned about 10,000ha.

Sir Richard bought Whitby more as an investment than as a residence. The monastic buildings of the abbey were dismantled for their materials, though the shell of the great church remained standing. His main residence was at Roxby, near Thornton-le-Dale, and Whitby seems to have been used mainly in the summer months. In the late 16th and early 17th centuries the family had two residences here. One was converted from the old abbey gatehouse: its exact location is unknown, but it probably stood somewhere near the west front of the abbey church and the churchyard. The other was probably the old abbot's lodging, to which Sir Richard's son Sir Francis (d.1586) added a timber-framed wing.

No further changes seem to have been made to the buildings at Whitby until shortly after Sir Hugh Cholmley I (1600–57) succeeded to the family estates in 1631. He found the two houses at Whitby too cramped, and moved into Fyling Hall, another family house nearby, but this was sold in 1634, and the family moved permanently to Whitby for the first time. Sir Hugh left a tantalizingly brief account of his work:

> I removed the spring following into the Gate-house at Whitby where I remained till my house was repaired and habitable, which was then very ruinous … and besides the repairs, or rather re-edifying the house, I built the

Above: A portrait of Sir Richard Cholmley, who acquired the abbey site soon after the Suppression, by an unknown artist
Right: Sir Hugh Cholmley I, depicted as a commander in full armour, probably painted about 1640. Sir Hugh defended nearby Scarborough Castle for the king against the Parliamentarians during a long Civil War siege in 1645

stable and barn, I heightened the out-walls of the court round the paddock, so that the place hath been improved very much, both for beauty and profit, by me more than all my ancestors.

Sir Hugh's 're-edifying' was a rebuilding of the old abbot's house. We know little about his house: it was probably built around a courtyard on the site of the present Abbey House, which probably represents its great hall and kitchen, much altered. The long row of buildings to the west of the outer court remains from Sir Hugh's time: these would have been the outbuildings, and have since been converted into private residences. Sir Hugh later wrote that he:

> lived in as handsome and plentiful fashion at home as any gentleman in all the country of my rank. I had between 30 and 40 in my ordinary family [i.e. household], a chaplain who said prayers every morning at six and before dinner and supper, a porter who merely attended the gates, which were shut up before dinner when the bell rang to prayers.

This comfortable way of life was not to last. Sir Hugh was created a baronet by Charles I in 1641, but he supported parliament on the outbreak of the Civil War. Repelled by the parliamentarians' religious extremism, however, he crossed over to the royalist side in 1643. Sir Hugh defended Scarborough Castle for the king, but was obliged to surrender it honourably in 1645. He went into exile in France, and parliamentarian forces led by Sir William Constable seized Sir Hugh's 'great house and Fort on the High Cliff' at Whitby.

Below: A reconstruction showing the ruins of Whitby Abbey and Abbey House in about 1680, after Sir Hugh Cholmley II had added a grand new wing and entrance court to the house built by his father. He also recorded that he planted many trees here

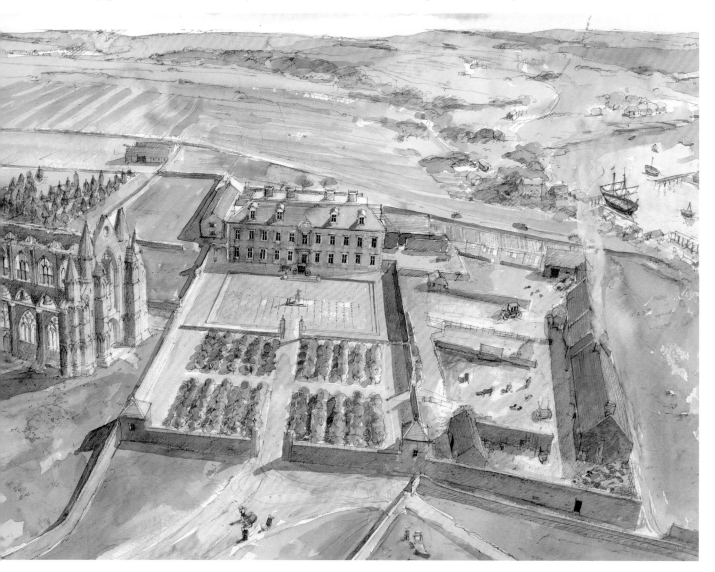

Right: An alum works in the Whitby area, painted by Havell and Son, and published in 1814. The mining and refining of alum, used to fix dyes in cloth, was a profitable enterprise for the Cholmley family

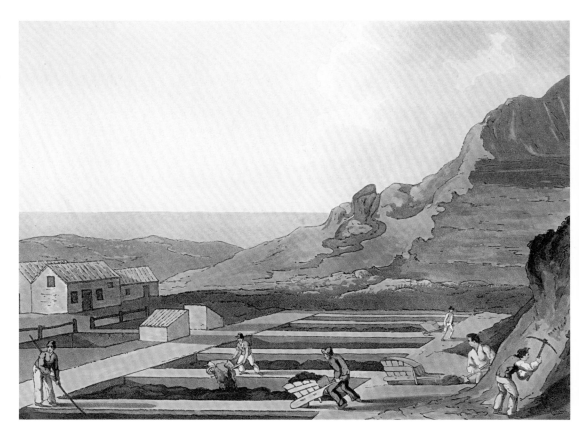

'a most delicate and stately hall ... with large courts and walks with iron grates, and a curious statue in solid brass as large as life in the midst of the square'
Ralph Thoresby (above), a historian and topographical writer, describing the Cholmleys' house in 1682; the statue was the Whitby Gladiator (page 16)

Sir Hugh returned from exile in 1649. He had left his estates in the hands of trustees and managed to recover them, but they had been plundered and impoverished. Once again, he responded energetically, developing the mining and refining of alum found nearby. Alum, or hydrated potassium sulphate, was used until the 19th century to fix dyes in cloth. It was a profitable enterprise, and Whitby itself was developing as a port, shipping alum, coal and other goods to London. Sir Hugh retired south, to live with his wife's family at Roydon Hall in Kent, where he was buried. The estates passed to Sir Hugh's younger son, Sir Hugh Cholmley II (1632–89).

Sir Hugh II was a man of energy and talent, and well connected at court: he was groom of the bedchamber to Charles II's Portuguese queen, Catherine of Braganza, an MP, and a man of wide abilities. At Whitby he helped his father develop the alum business, building a new pier there, and in the 1670s he became surveyor-general of a project to build a huge new harbour mole at Tangier, recently acquired by England as part of Catherine's dowry. He spent the summer of 1672 in Yorkshire 'finishing my new buildings': this is

our only evidence for the date of the new wing which he added to his father's house. He collected paintings, and planted trees there. Sir Hugh's ledger books record much expenditure at Whitby, but despite this he seems to have spent little time at the house. He built another residence, Walcot Hall, near his wife's family home in Northamptonshire, and he lived mainly there and in London. Nevertheless, on his death in 1689 Sir Hugh was buried in the parish church at Whitby.

On Sir Hugh II's death the Cholmley baronetcy died out. He was succeeded by his daughter Mary (d.1748), who had married a cousin, Nathaniel Cholmley (d.1687), a diamond merchant in the East India trade. Their son, another Hugh Cholmley (d.1755), inherited. He lived at Whitby until 1743, when his wife inherited her family seat, Howsham Hall near Malton. The family moved there, and do not seem to have lived at Whitby again. Hugh's son Nathaniel (d.1791) was the last of the family to take an active interest in the Whitby estates, building a fine new town hall in 1788. When the roof of the new wing of the Abbey House was blown off by a gale in 1790, however, it was dismantled and left as a shell.

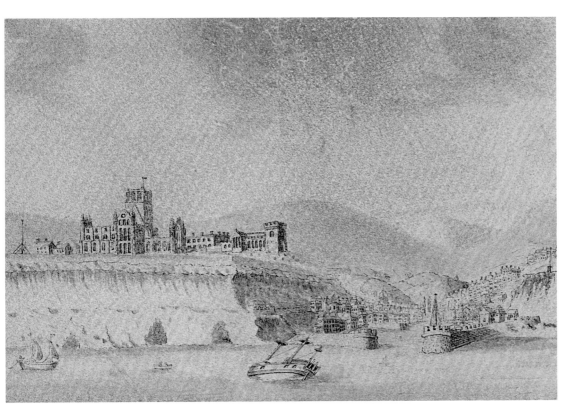

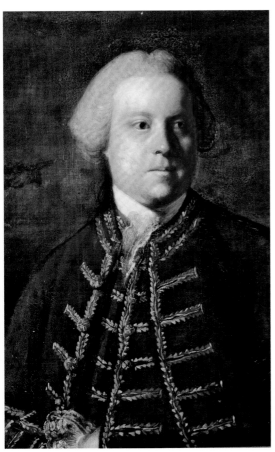

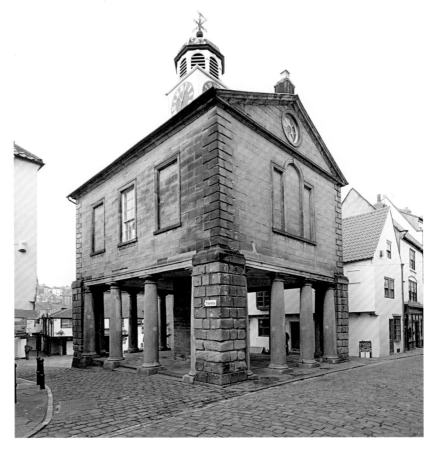

Left: A view of Whitby Abbey and harbour from the sea, from a map by Francis Gibson of about 1790

Below left: Nathaniel Cholmley (d.1791), painted by Sir Joshua Reynolds in 1762. Nathaniel was the last of the Cholmleys to take an interest in the family's Whitby estates

Below right: The old Whitby town hall or tollbooth, designed by Jonathan Pickernell and built by Nathaniel Cholmley in 1788

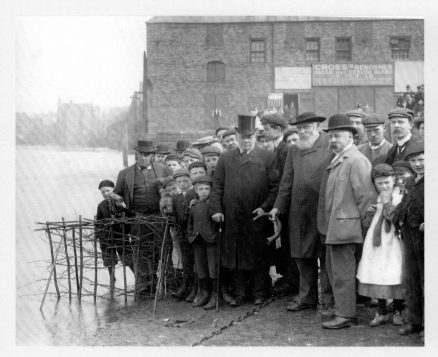

The 'Penny Hedge' Ceremony

The 'Penny Hedge'
is so ancient that
even in the 14th
century its original
meaning had
been forgotten

Many English towns and villages carry out ancient rituals and ceremonies, and Whitby has one of the oldest and most mysterious. Each year on the eve of Ascension Day, usually in May, townspeople cut wooden stakes and green branches and take them to a specific place on the tidal foreshore. They build a length of woven hedge with stakes a yard apart, which must be strong enough to remain standing for three tides. When it is finished, the 'bailiff' blows a horn, and shouts 'Out on Ye' three times. The ceremony is called the 'Penny Hedge', interpreted as meaning the 'penance hedge'.

The story behind this strange tradition is that in 1158 a group of locals were hunting a wild boar which took refuge in a holy man's hut. They pursued the boar, and accidentally wounded the hermit. As he lay dying, he ordered them to carry out this annual task under the abbot's supervision, to show their repentance.

There are accounts of the ceremony, then called the 'Horngarth', being carried out by the abbey's main tenants as part of their rental obligations in the 14th century. At dawn, the tenants cut wood under the direction of the abbot's bailiff, brought it by a particular route to the water-edge, and built the 'hedg which should stand three tydes, and then the

officer did blow owte upon they'. In later centuries the Cholmleys' stewards and the townspeople kept up the tradition, which continues today.

The story of the hermit was probably invented by Whitby Abbey to buttress its authority, but it does not seem to explain the ceremony. This suggests that the 'Penny Hedge' is so ancient that even in the 14th century its original meaning had been forgotten. Canon Atkinson, a local historian, established that the ceremony dated at least as far back as the foundation of the abbey. He thought that 'Horngarth' related to the building of fences to keep horned cattle away from crops. This does not seem satisfactory: if the ceremony originated in something so everyday and useful, why would it evolve into something so bizarre and apparently pointless? Another historian, Robert Turton, suggested that the Penny Hedge embodies a folk memory of a funnel of fencing set up for the rounding up and slaughter of 'horned stock'; but it would not make sense to slaughter livestock in May, when they would still be thin after the winter. Equally, no one has yet come up with an explanation for the words 'Out on Ye'. So the Penny Hedge remains satisfyingly obscure: a genuinely ancient ceremony, whose origins are forgotten.

Above: A photograph of the Penny Hedge ceremony in the 1920s
Above right: The Penny Hedge ceremony in 2009

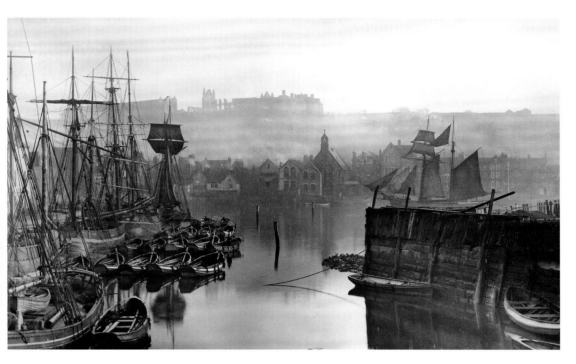

Left: Whitby harbour, photographed in 1880 by Frank Meadow Sutcliffe. The abbey and headland can be seen in the background
Below left: Captain William Scoresby (1760–1829), Whitby's most famous whaler. His son, also William, became a celebrated explorer and scientist
Below: The Captain Cook monument on the West Cliff at Whitby, erected in 1912 to commemorate the famous explorer, who served his apprenticeship at Whitby

WHITBY TOWN

Whitby prospered in the 18th century, partly thanks to the Cholmleys' development of the alum mines and stone quarries, and partly from its whaling and fishing industry, and the development of the Baltic and Greenland trades. Whitby's most famous son in the 18th century was Captain James Cook (1728–79). He was born just up the coast at Marton, but began his extraordinary career as a sailor and explorer at Whitby.

By the end of the century Whitby was also developing a new identity as a resort. The Napoleonic Wars, which prevented English people from travelling on the Continent, did much to encourage 'picturesque' tourism at home, and Whitby possessed a capital asset in the abbey ruins. This new antiquarian interest was reflected in numerous prints, watercolours and drawings of the abbey.

The Pickering and Whitby Railway was opened as a horse-drawn operation in 1836. It was bought by the 'Railway King' George Hudson in 1845, and converted to steam operation in 1847, when the present railway station was built. With the town now accessible by rail, the West Cliff developed steadily as a seaside resort. Victorian Whitby was a busy place, with its working harbour dealing in fish, timber, stone and alum, as well as an increasing stream of tourists.

By this time the headland or East Cliff represented the past: the Cholmleys had left and Abbey House was half ruined. In 1857 the Cholmleys' Whitby estates passed to a cousin, Sir George Strickland (d.1874), of Boynton Hall, near Bridlington. Sir George gave Whitby Abbey House to his son Charles, later Sir Charles Strickland (d.1909), and in about 1866 he added another wing to the house, to make it a habitable residence again. Charles Strickland also built the picturesque gatehouse, which stands just below the west front of the abbey ruins, as the new entrance, and he

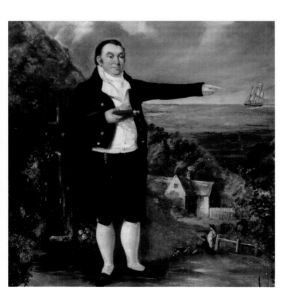

repaired the shell of Sir Hugh II's wing, apparently appreciating its value as a ruin.

The rich fossil deposits in the Whitby cliffs provided an added attraction for serious-minded Victorian tourists. In the 19th century Whitby developed a new industry making jewellery and ornaments of jet, the polishable black coal-like stone which was mined locally, and which was very appealing to Victorian taste.

The publication of Bram Stoker's novel *Dracula* in 1897 gave Whitby a major literary association: Stoker has the count come ashore at Whitby in the form of a dog, and Dracula attacks his first victim in England, Lucy Westenra, in the churchyard. The sinister count has since passed into popular culture.

THE RECENT PAST

The Stricklands' return to Whitby was short-lived. Although Sir Charles had rebuilt Whitby Abbey House, in 1896 he leased it to the Co-operative Holidays Association for use as a guest house. After Sir Charles's death in 1909 the estates were divided, and most of the family's property on the headland was sold in 1928. The abbey ruins were taken into care by the Ministry of Works, and in the 1920s Sir Charles Peers, the Principal Inspector of Ancient Monuments, organized major clearance work and archaeological excavation on the site.

Whitby's exposed coastal position made it vulnerable to enemy attack. On 14 December 1914, four vessels of the Imperial German Navy

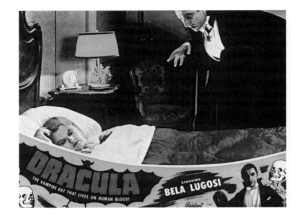

appeared off the headland and fired on the town from a range of a mile and a half, damaging the signal station, the coastguard cottages and the west end of the abbey itself. In 1939 the first enemy aircraft to be brought down on English soil was a Heinkel bomber, shot down nearby by Hurricanes from RAF Acklington. Since then, Fylingdales, in the North York Moors, has been the seat of a new generation of defences, the site of one of NATO's principal early warning stations since the 1960s.

Whitby was long exposed to raiders from the sea, who had a dramatic impact on its history at various stages. These threats, at least, have passed, and the town and its abbey are now host to a more peaceable invasion, of thousands of visitors drawn by the sea, the picturesque harbour town, the landscape and the dramatic ruins. Whitby remains at the mercy of its most ancient assailants, the wind and the sea.

Above: A Victorian mourning locket, made from Whitby jet
Above right: A poster for the 1931 horror film Dracula, which starred Béla Lugosi in the title role. Bram Stoker set several scenes from his 1897 novel in Whitby, ensuring that Dracula would forever be associated with the town
Right: The abbey ruins, seen from the churchyard